VINCENT
VAN GOGH

The Healing Power
of Nature

The Van Gogh Museum is grateful that you
are directly contributing to the preservation
of Van Gogh's legacy and art collection so that
it may continue to inspire and be shared with
future generations.

vangoghmuseum.nl

Digital edition: Vincent van Gogh, The Letters.
Ed. Leo Jansen, Hans Luijten and Nienke Bakker.
Amsterdam 2009.

vangoghletters.org

First published in 2022 by September Publishing

Text design by Studio April

Printed in Poland by L&C Printing Group

ISBN 9781914613043

10 9 8 7 6 5 4 3 2

September Publishing
septemberpublishing.org

CONTENTS

In a letter from 1874 to his beloved brother Theo, Vincent van Gogh famously noted, 'If one truly loves nature one finds beauty everywhere.' His own art and writings remain an enduring testament to the truth of this insight. As the mostly lesser-known images and quotes gathered in these pages show, Van Gogh possessed a remarkable talent for describing the beauty of the natural world in words as well as paint. He shows how nature can become a source of great healing and inspiration, connecting us with the peace and beauty of our surroundings and with a sense of something even greater.

Each quote is taken from Van Gogh's personal correspondence – some 1,750 letters written between 1853 and 1890,

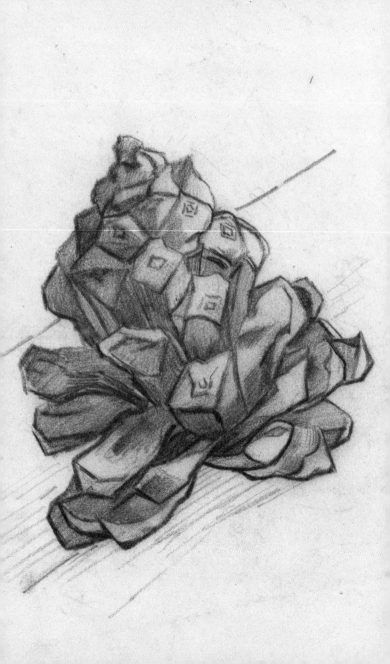

which have been translated from Dutch and French by the Van Gogh Letters Project. The images alongside them have been selected from the collection of the Van Gogh Museum. In their emphasis on the importance of nature, Vincent's letters and artworks speak as urgently and powerfully to us today as they have ever done.

Sue Belfrage

CONNECTION

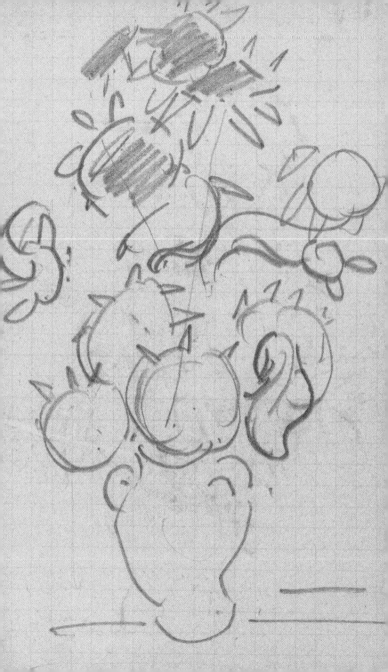

'I see a chance of giving a felt impression of what I see.

'Not always literally exactly – rather never exactly – for one sees nature through one's own temperament.'

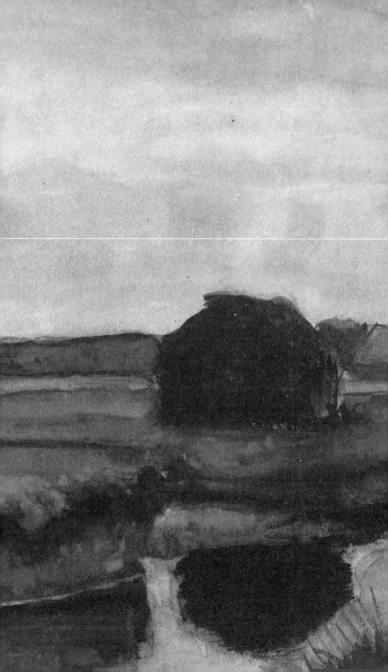

'We've often parted from each other already, though this time there was more sorrow than before, on both sides, but courage as well, from the firmer faith in, and greater need for, blessing. And wasn't it as though nature sympathized with us? It was so grey and rather dismal a couple of hours ago.

'Now I look out over rolling pastures, and everything is so quiet and the sun is setting behind the grey clouds and throws a golden glow across the land. How much we long for each other, those first hours after parting ...'

en bid en voor het

h van dit soort gevallen eeni[g]

er heb ik hard voor — zooal, dee

voort bewaren —

'I'm now working on still lifes of my birds' nests, and I've finished 4 of them. I think that some people who know nature well might like them because of the colours of the moss, dry leaves and grasses, clay &c. ...

'In the winter, when I have more time for it, I'll make several drawings of this sort of thing. I feel for *the brood and the nests* – particularly those *human* nests, those cottages on the heath and their inhabitants.'

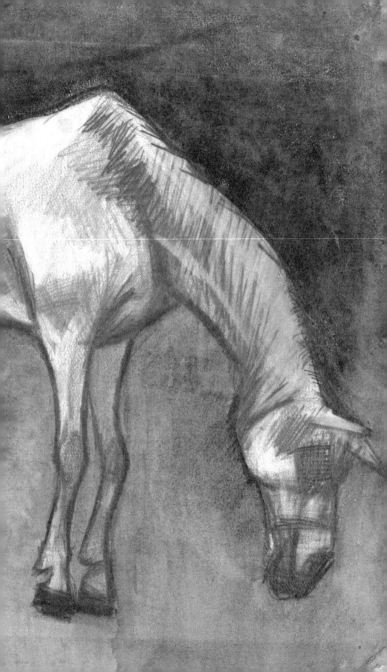

'Those nags, those poor, sorry-looking nags, black, white, brown, they stand there, patiently submissive, willing, resigned, still. They'll soon have to drag the heavy boat the last bit of the way, the job's almost done. They stand still for a moment, they pant, they're covered in sweat, but they don't murmur, they don't protest – they don't complain – about anything. They're long past that, years ago already. They're resigned to living and working a while longer, but if they have to go to the knacker's yard tomorrow, so be it, they're ready for it. I find such a wonderfully elevated, practical, wordless philosophy …

'… to know how to suffer without complaining, that's the only practical thing, that's the great skill, the lesson to learn, the solution to life's problem.'

'To my mind, anyone who turns away from nature, whose head always has to be full of keeping this up or keeping that up, even if things like that take him away from nature, to such an extent that he can't help saying it – oh – in this way one so easily arrives, in my view, at a point where one can no longer distinguish white from black – and – and one becomes precisely the opposite of what one is taken to be or thinks oneself to be.'

'The sea isn't always picturesque either,
but one has to look at those moments
and effects as well if one doesn't want to
deceive oneself as to its true character.'

'Rarely of late has the stillness, nature
alone, so appealed to me. Sometimes
it's precisely those spots where one no
longer feels anything of what's known as
the civilized world and has definitely left
all that behind – sometimes it's precisely
those spots that one needs to achieve calm.'

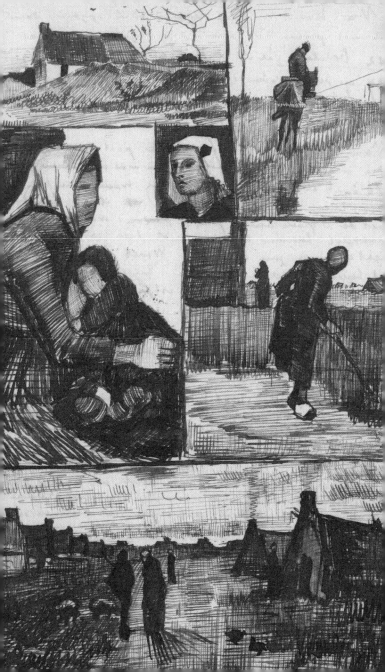

'I saw it once in real life, not the birth of the baby Jesus, mind you, but the birth of a calf. And I still know exactly what its expression was like. There was a girl there, at night in that stable – in the Borinage – a brown peasant face with a white night-cap among other things, she had tears in her eyes of compassion for the poor cow when the animal went into labour and was having great difficulty. It was pure, holy, wonderfully beautiful …'

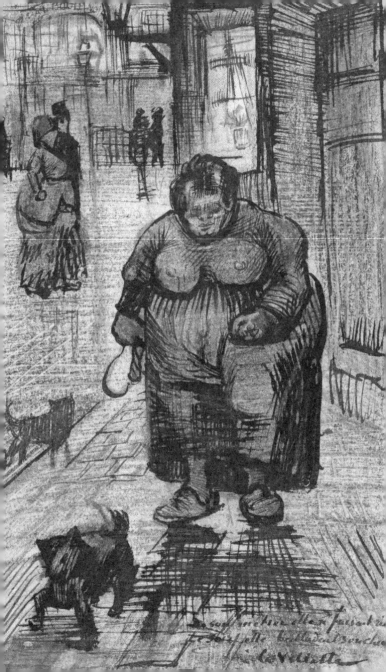

'In short – it's a dirty animal.

'Very well – but the animal has a human
history and, although it's a dog, a
human soul, and one with finer feelings
at that, able to feel what people think
about him, which an ordinary dog
can't do.

'And I, admitting that I am a sort of dog,
accept them as they are.'

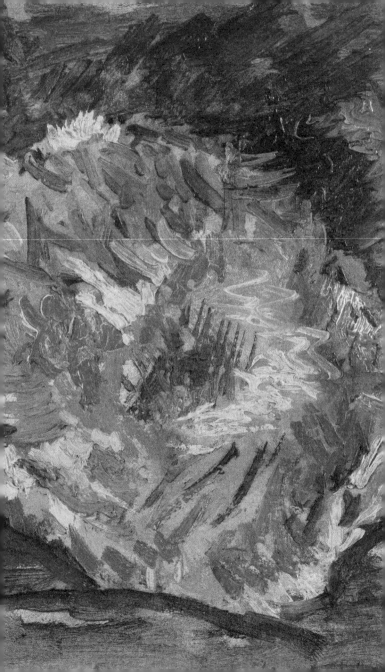

'… the desire comes over me to remake myself and try to have myself forgiven for the fact that my paintings are, however, almost a cry of anguish while symbolizing gratitude in the rustic sunflower.'

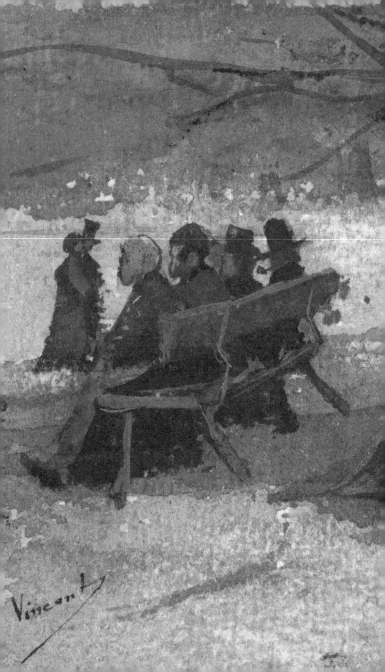

'Above those roofs, one single star, but a nice, big friendly one. And I thought of us all …'

CONTEMPLATION

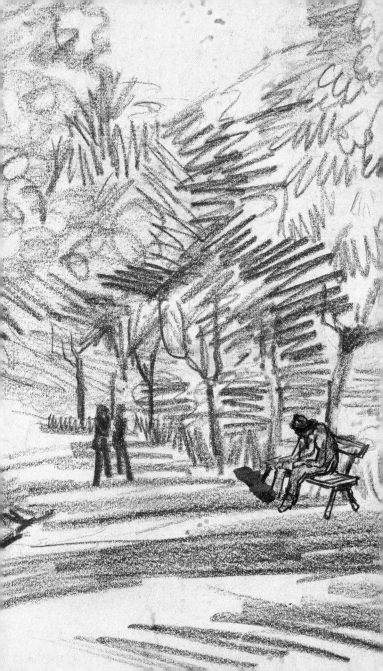

'Always continue walking a lot and loving nature, for that's the real way to learn to understand art better and better. Painters understand nature and love it, and teach us to see.'

Ik voor my vooral als gy hier waart zou
zet meer en meer af/zyner me concentreere
Ik zou U even die landschappen op krabbelen
die ik op 't oogel heb.

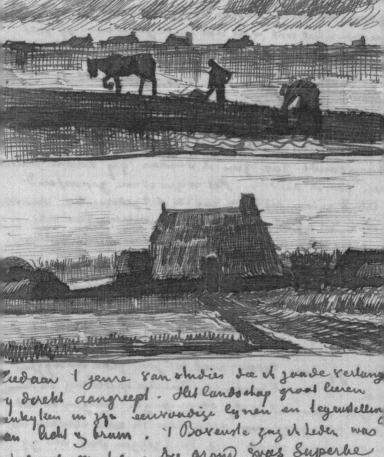

Ziedaar 't genre van studies die ik zonder verlang
y derekt aangreept. Het landschap groots leeren
enkyleen en zyn eenvoudige lynen en tegenstellin
en licht y bruin. 't Boertste zag ik leder was
schul n de Michel. Die grond was Superbe
de natuur. Myn studie is my nog niet ryp geno
maar het effekt greep my aan en was wel qua
licht y bruin zoo als ik by 't hier teeken

'I have a simple plan for myself, I'll go
out and make whatever strikes me,
fill my lungs with heathland air, believe
that in a while I'll be fresher, newer,
better myself.'

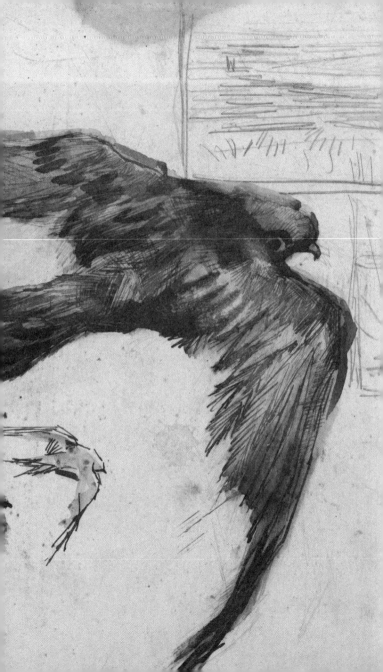

'In the springtime a bird in a cage knows very well that there's something he'd be good for; he feels very clearly that there's something to be done but he can't do it; what it is he can't clearly remember, and he has vague ideas and says to himself, "the others are building their nests and making their little ones and raising the brood", and he bangs his head against the bars of his cage. And then the cage stays there and the bird is mad with suffering … I'm in a cage, I'm in a cage, and so I lack for nothing, you fools! Me, I have everything I need! Ah, for pity's sake, freedom, to be a bird like other birds!

'An idle man like that resembles an idle bird like that.'

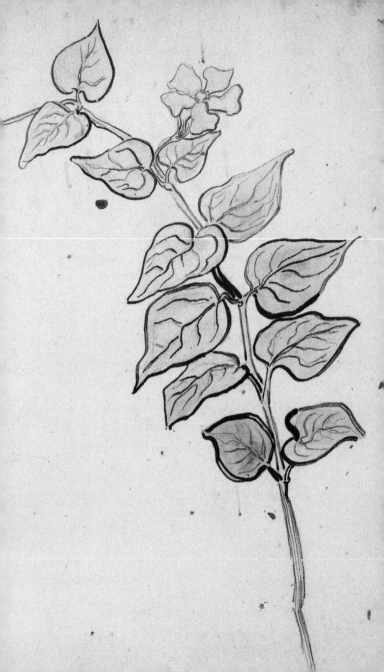

'Copying nature absolutely isn't the
ideal either, but knowing nature in such
a way that what one does is fresh and
true – that's what many now lack.'

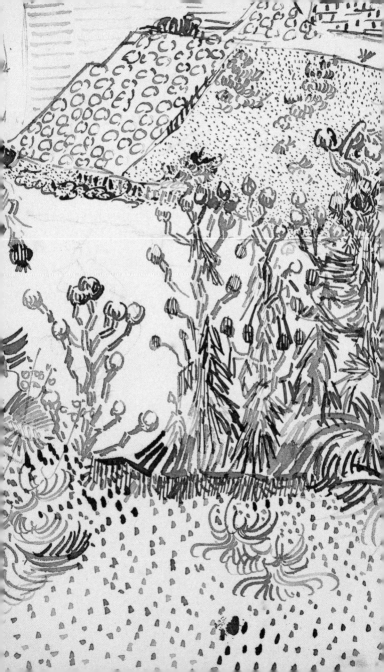

'I continue to believe one thing:
wrestling with nature is not working in
vain, and though I don't know what the
result will be, there will be a result.'

nemen moet - Dit
maar in de aquarel zelf

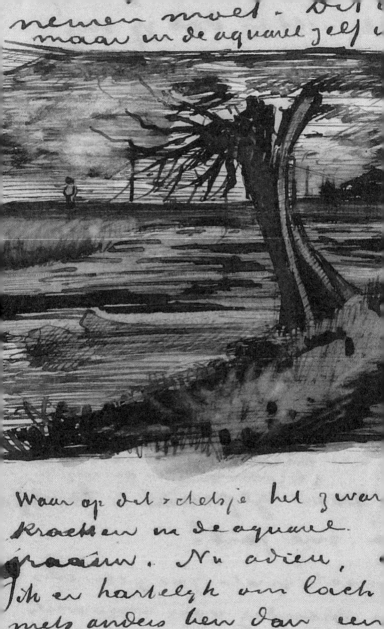

Waar op dit schetsje het zwar
krachten in de aquarel
raaiuw. Nu adieu,
Ik en hartelijk om lach
niets anders ben dan een
studie van werk — ook

'Just working faithfully from nature and
with persistence seems to me a sure way,
and one that *can't* end up with nothing.
The feeling for and love of nature always
strike a chord sooner or later with
people who take an interest in art.
The duty of the painter is to study
nature in depth and to use all his
intelligence, to put his feelings into his
work so that it becomes comprehensible
to others.'

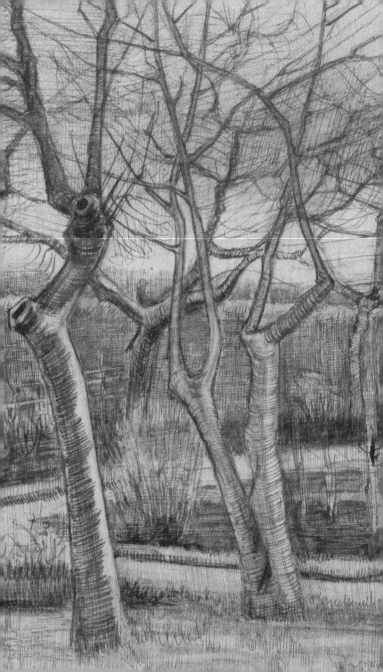

'Nature always begins by resisting the draughtsman, but he who truly takes it seriously doesn't let himself be deterred by that resistance, on the contrary, it's one more stimulus to go on fighting, and at bottom nature and an honest draughtsman see eye to eye.'

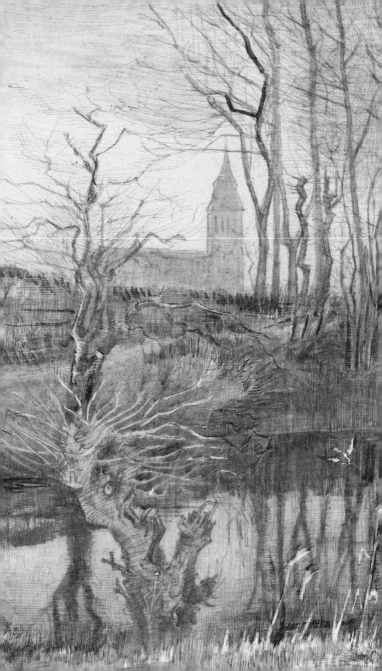

'I think that a painter is happy because he's in harmony with nature as soon as he can depict, to some extent, what he sees.

'And that's a great deal.'

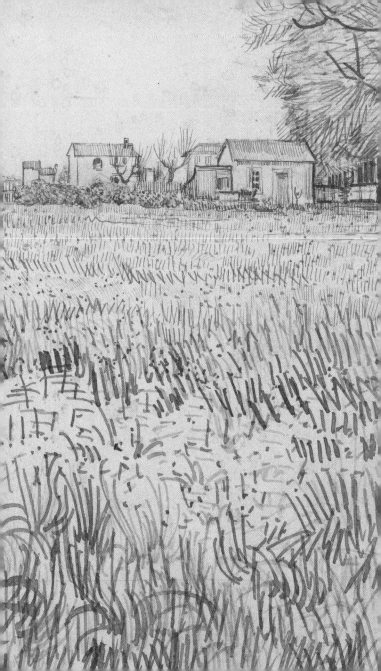

'And yesterday while out walking
I saw dandelions already in flower in
the meadows, which will be shortly
followed by the daisies and violets.'

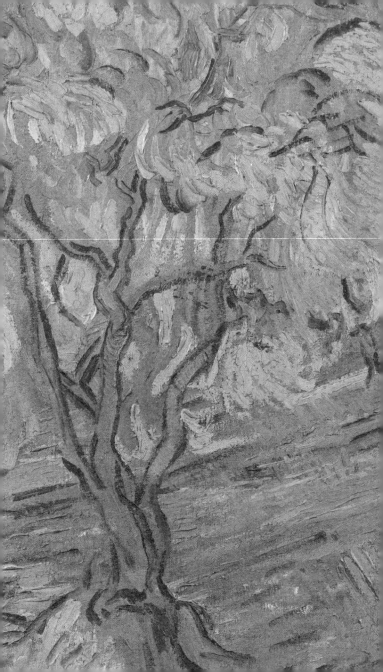

'I have a terrible clarity of mind at
times, when nature is so lovely these days,
and then I'm no longer aware of myself
and the painting comes to me as if in
a dream.'

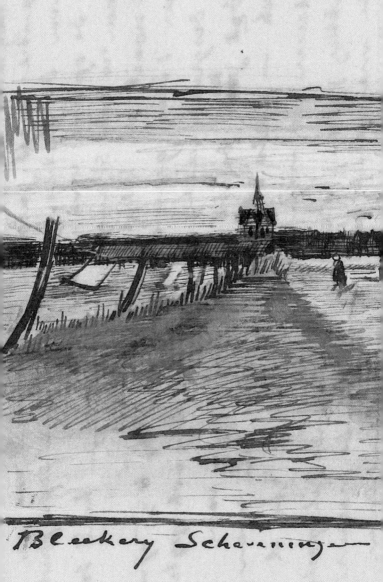

Bleekery Scheveninge

'But, again, anyone who works with
love and with intelligence has a kind of
armour against people's opinion in the
sincerity of his love for nature and art.

'Nature is severe and hard, so to speak,
but never deceives and always helps you
to go forward.'

COLOUR AND FORM

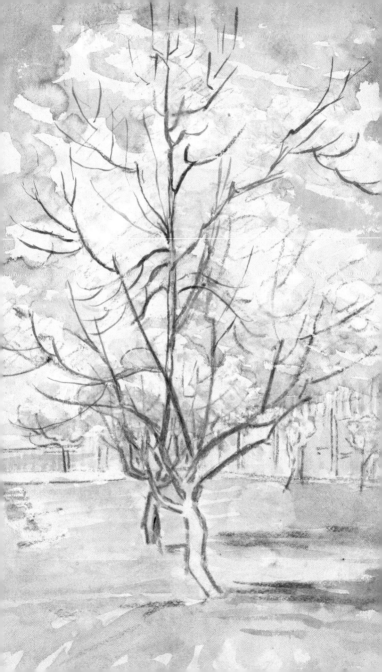

'The spring is tender green (young wheat) and pink (apple blossom).

'The autumn is the contrast of the yellow leaves against violet tones.

'The winter is the snow with the little black silhouettes.

'But if the summer is the opposition of blues against an element of orange in the golden bronze of the wheat, this way one could paint a painting in each of the contrasts of the complementary colours (red and green, blue and orange, yellow and violet, white and black) that really expressed the mood of the seasons.'

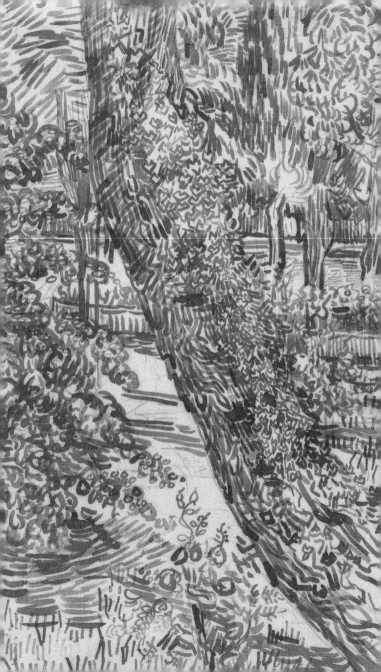

'In the face of nature it's the feeling for
work that keeps me going.'

maer het my niet kwalyk nemen dat
us schryf ——— het is om u te zegg
en het schilderen zoo by zonder ple
l. Zaturdag avond heb ik een ding a
ik al dikwyls van gedroomd had —
is een gezegt en de vlakke groene we
hoopen hooi. Een kolenweg met
arye loopt dwars er door,
aan den horizon midden en 't a
door vuurrood onder,

Kom 't effekt onmogelyk zoo en
enen doch z ich ne de compositie
en 't was geheel een kwestie van
schakeering van de gamma kleuren
een lilas nevel _ waarin de roode z
een donkerpaarsche wolk met schitterend
zon reflectes van vermiljoen, ma
shook geel Dat groen werd en
wachtig het zoogenaamde Cerulean blue en dan
2 graauwe wolken die reflecta
de zon

'I can't possibly draw the effect quickly here, but this shows the composition.

'Yet it was all a question of colour and tone, the gradations of the range of colours in the sky, first a lilac haze – inside it the red sun, half covered by a dark purple cloud with a delicate edge of gleaming red; beside the sun vermilion reflections, but above a yellow band that turned green and higher up bluish, the so-called *Cerulean blue*, and here and there lilac and greyish clouds catching reflections from the sun.

'The ground was a sort of tapestry of green – grey – brown, but full of different shades and movement – the water of the ditch gleams in that tonal ground.'

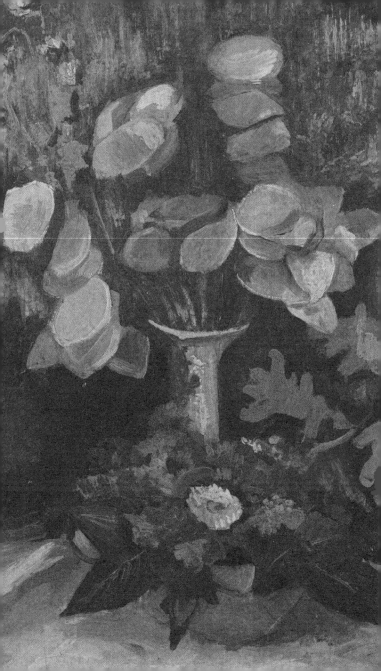

'The colourist is he who on seeing
a colour in nature is able to analyze it
coolly and say, for example, that green-
grey is yellow with black and almost
no blue, &c. In short, knowing how
to make up the greys of nature on
the palette.'

het schilderen een gaaf is — nu ja ...
... je 't doen voorkomen men moet ...
het nemen en dat nemen is iets moeijelijks niet wachten tot het v...

Er is wel iets maar 't is volstrekt ...
voorkomen al doende leert men ...
... schilder. Wil men schilder wor...
... men wat zij voelt dan kan men ...
... gepaard met moeite zorgen ...
... melankolie van onmagt en dat alles ...
. Ik vind dat zoo'n zuffery dat ik even een kru...
... denken neem mij niet kwalijk ik zal daar maar niet ...

... er nog eens op komen dat de jongen ...
... dat dit wel zoo veel opzijzien een ma...
... nu gevonden worden De natuur zoo bij zo...
graf aan den gang houdt gaan 't zou ...
... maar een dicht frisch worstelen ...
... dicht mogelijk.
... de wereld zouden we met zoo veel ...
veel energie zooveel leukheid het ...
... hellen door — al hadden we seri...

'Today I walked behind the ploughmen who were ploughing up a potato field, and women walking behind them picking up a few potatoes that were left.

'This was a very different field from the one I scribbled for you yesterday, but this is the singular thing about it here, always precisely the same and yet just that variation; the same subjects as in paintings by masters who work in the same genre and yet differ, oh it's so singular here – and *so* quiet, *so* peaceful. I can find no other word for it but peace.'

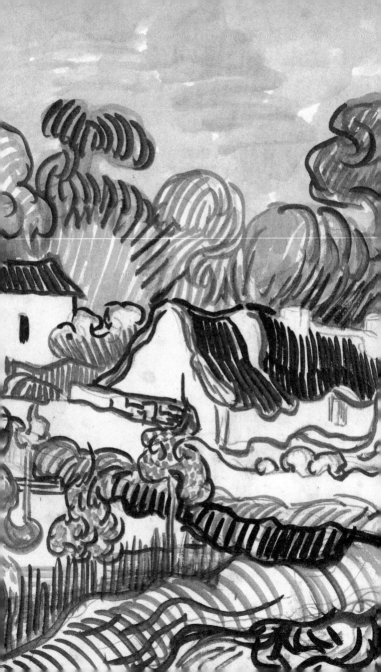

'Because instead of trying to render
exactly what I have before my eyes,
I use colour more arbitrarily in order
to express myself forcefully.'

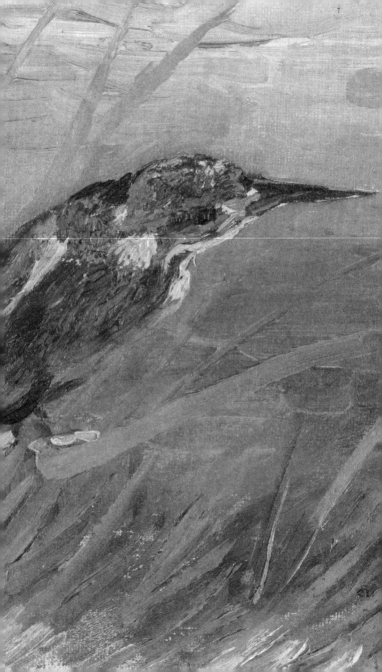

'I retain from nature a certain sequence and a certain correctness of placement of the tones, I study nature so as not to do anything silly, to remain reasonable – but – I don't really care whether my colours are precisely the same, so long as they look good on my canvas, just as they look good in life …

'Although I believe that the finest paintings are made relatively freely from the imagination, I *can't* break with the idea that one can't study nature, swot even, too much.'

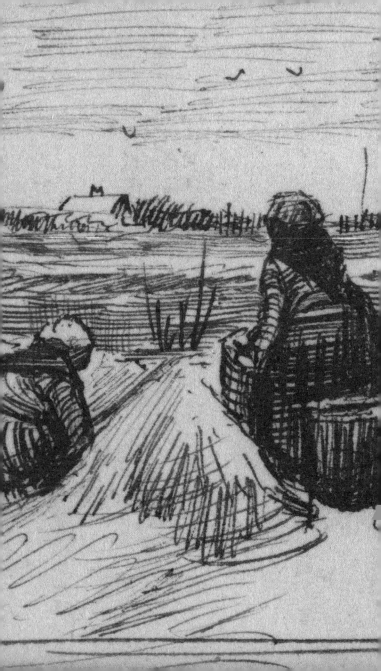

'That the beautiful effects of the light in nature require one to work very fast.'

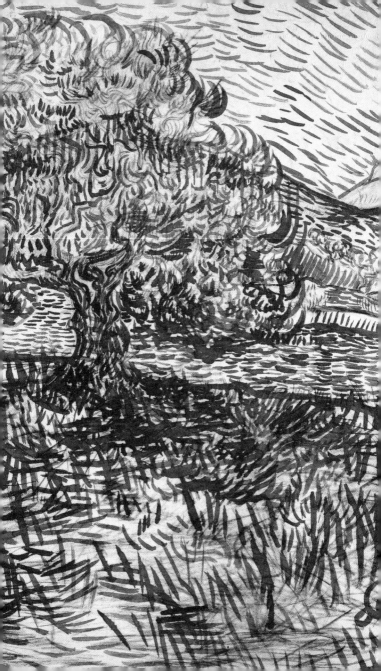

'The effect of daylight, of the sky, means
that there is an infinity of subjects to be
drawn from the olive tree. Now I looked
for some effects of opposition between
the changing foliage and the tones of
the sky. Sometimes the whole thing is
wrapped in pure blue at the time when
the tree bears pale blossoms and the
numerous big blue flies, the emerald
rose beetles, finally the cicadas, fly
around it. Then, when the more bronzed
greenery takes on riper tones the sky is
resplendent and is striped with green and
orange; or even further on in the autumn,
the leaves take on the violet tones
vaguely of a ripe fig, the violet effect will
be displayed in full by the oppositions of
the large whitening sun in a halo of clear,
fading lemon.'

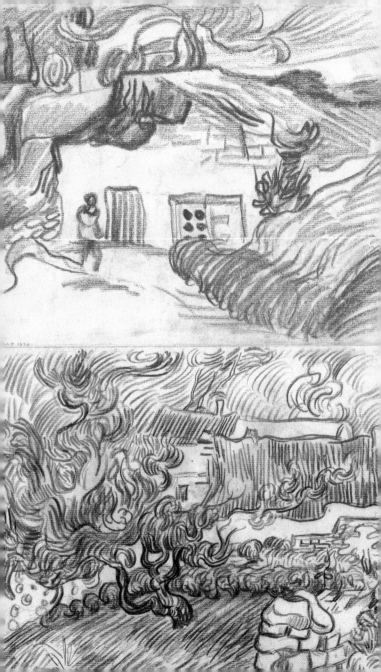

'This vertical small farmhouse garden is superbly coloured in reality. The dahlias are a rich and dark purple, the double row of flowers is *pink and green* on one side *and orange* almost without greenery on the other. In the middle a low, white dahlia and a little pomegranate tree, with flowers of the most brilliant orange red, yellow-green fruit, the ground grey, the tall reeds – "canes" – of a blue green, the fig trees emerald, the sky blue, the houses white with green windows, red roofs. In full sun in the morning, in the evening entirely bathed in shadow cast by the fig trees and reeds.'

SIMPLICITY

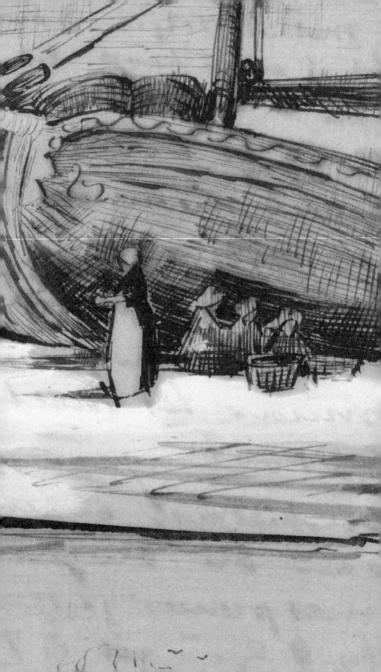

'I have an everlasting nostalgia for heath
and pine-woods with the curious figures.
A woman gathering wood, a peasant
fetching sand – in short, that simplicity
that has something grand like the sea.'

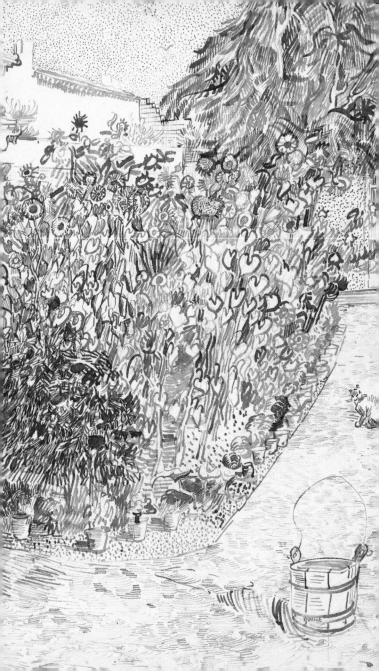

'It wouldn't be good if, when drawing from nature, I lapsed into too much detail and overlooked the important things. And I found much too much of that in my last drawings.'

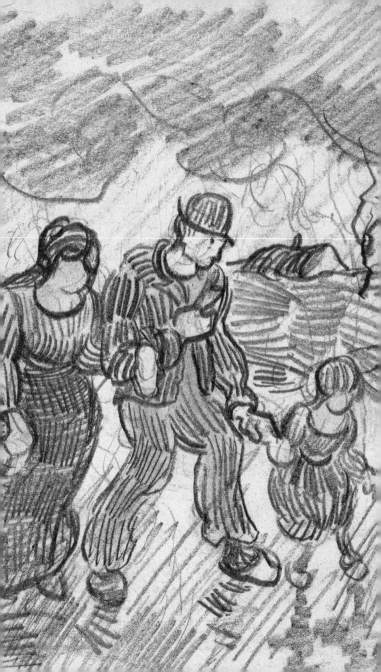

'… I think that the country air has an enormous effect. In the street here there are kids born in Paris and really sickly – who however are well.'

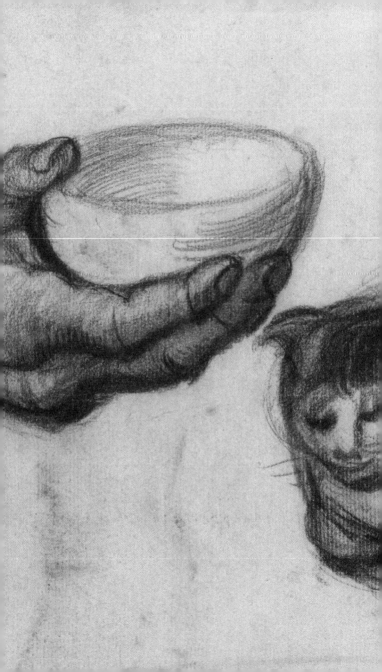

'I always find it wonderfully cosy to sit by a fire in the dusk and to look through the window at a snow-covered landscape.'

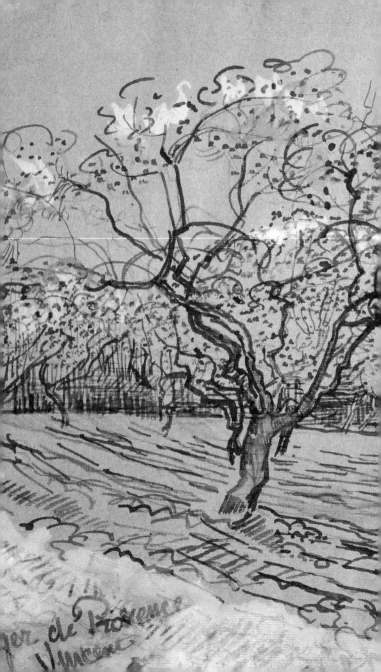

'Ah, while I was ill, damp, melting snow
was falling, I got up in the night to
look at the landscape – never, never
has nature appeared so touching and so
sensitive to me.'

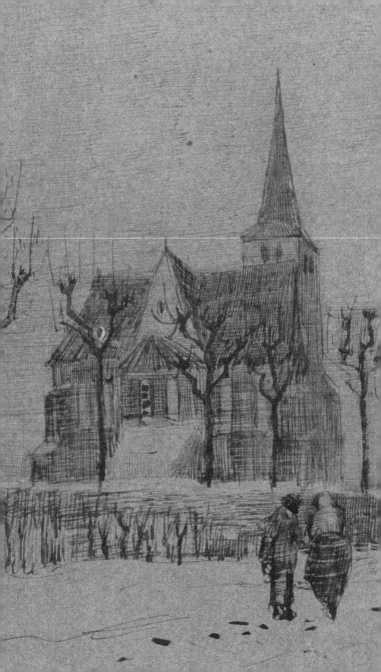

'It had snowed and everything was so still, the only thing one saw was a little light here and there in one or two upstairs rooms and, in the snow, the black figure of the rattle-man. It was high tide, and the canals and boats looked dark against the snow. It can be so beautiful there by those churches. The sky was grey and foggy, and the moon shone faintly through it.'

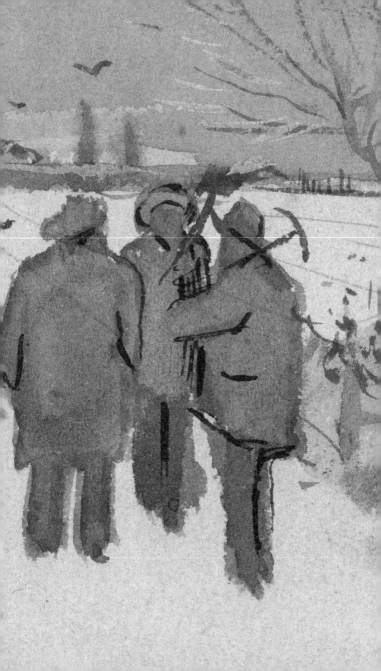

'Diggers, sowers, ploughers, men and
women I must now draw constantly.
Examine and draw everything that's part
of a peasant's life. Just as many others
have done and are doing. I'm no longer
so powerless in the face of nature as
I used to be.'

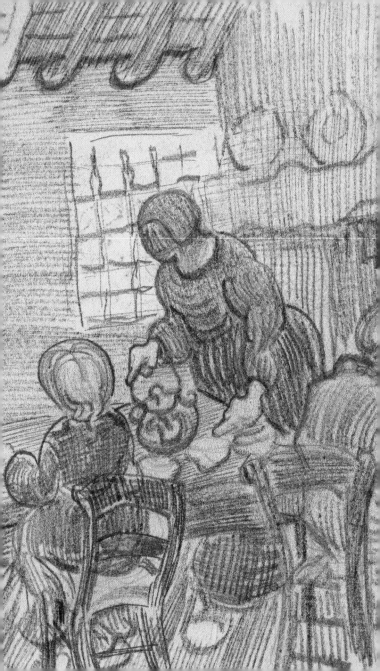

'The youngest take the sheep to the pastures, the others who are older already lead the large flocks, the eldest plough with their father. Meanwhile, the mother of the whole family prepares a simple meal for her husband and her beloved children, who will return weary from the day's work; she takes care of milking her cows and her ewes, and we see streams of milk flowing; she makes a big fire, around which all the innocent, peaceful family takes pleasure in singing, the whole evening long, while waiting for sweet sleep. ... All toil's evils end with the day. Sleep soothes black care with its spell, and holds all nature in a sweet enchantment; each one falls asleep without foreseeing the morrow's troubles.'

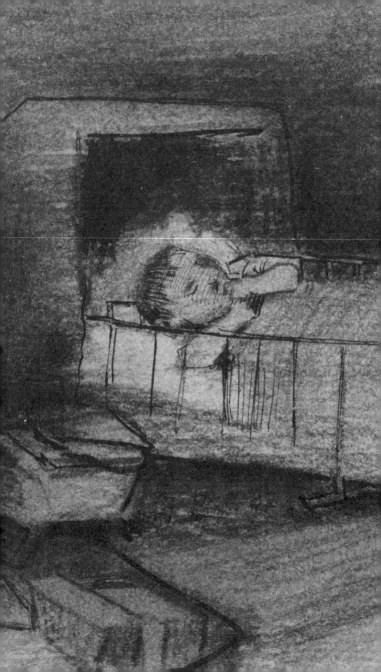

'I've now been breathing heathland air
for a month, I absolutely needed it too
– I went and sat by a peasant's peat fire
with a cradle beside it.

'I speak calmly, I think calmly now.'

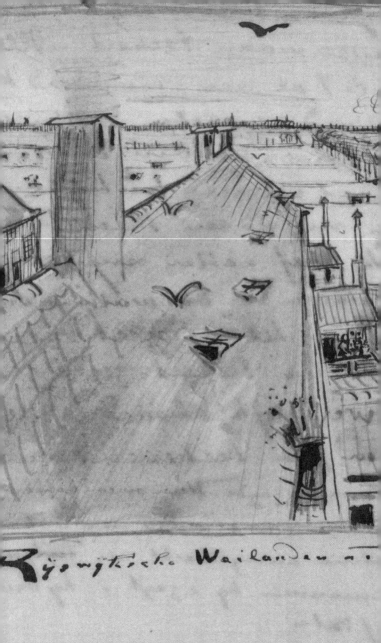

Rijswijkeche Wailanden

'So you must imagine me sitting at
my attic window as early as 4 o'clock,
studying the meadows and the carpenter's
yard with my perspective frame – as the
fires are lit in the court to make coffee,
and the first worker ambles into the yard.

'Over the red tiled roofs comes a flock
of white pigeons flying between the
black smoking chimneys. But behind
this an infinity of delicate, gentle green,
miles and miles of flat meadow, and
a grey sky as still, as peaceful as Corot
or Van Goyen.'

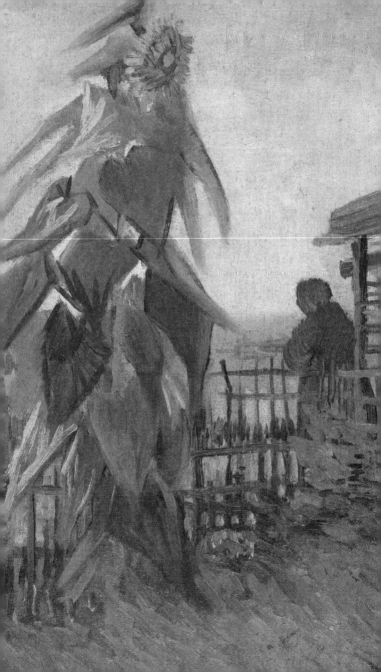

'… I console myself by reconsidering the sunflowers.'

HEALING

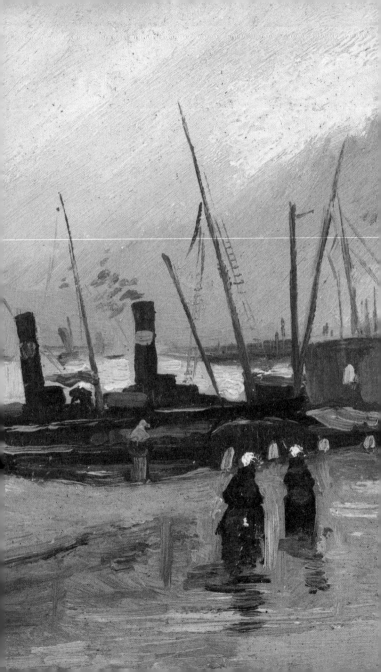

'A terrible storm blew up here this morning at quarter to 5, a little while later the first stream of workers came through the gate of the dockyard in the pouring rain. … Again and again one heard thunder and saw lightning, the sky looked like a painting by Ruisdael, and the gulls were flying low over the water.

'It was a magnificent sight, and really refreshing after the oppressive heat of yesterday. It has refreshed me, because I was awfully tired when I went upstairs yesterday evening.'

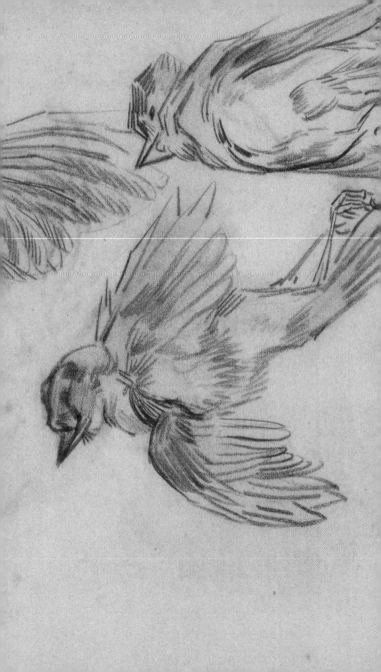

'... I've had a time of nervous, barren stress when I had days when I couldn't find the most beautiful countryside beautiful, precisely because I didn't feel myself part of it. That's what pavements and the office – and care – and nerves – do.'

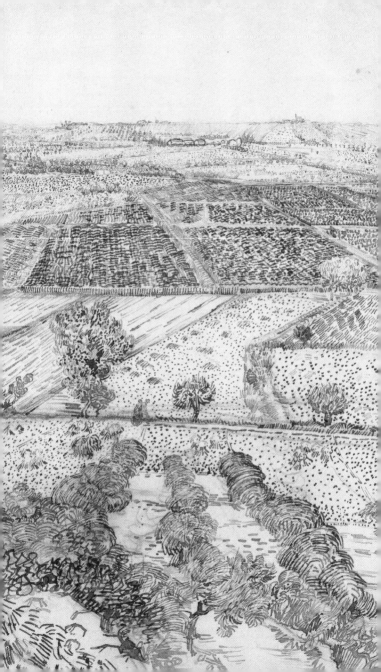

'You enquire after my health, but how's yours? I believe that my remedy could also be yours. Being outdoors, painting.'

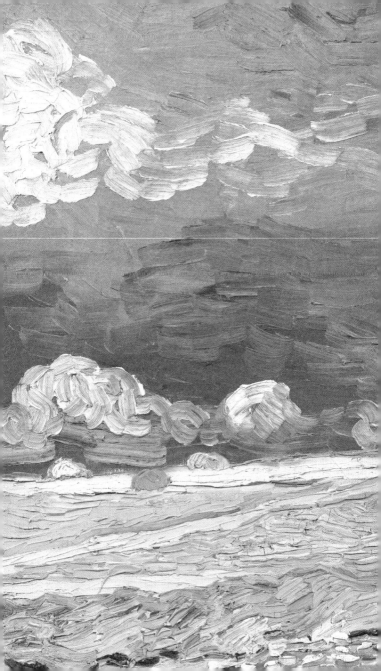

'I'd almost believe that these canvases
will tell you what I can't say in words,
what I consider healthy and fortifying
about the countryside.'

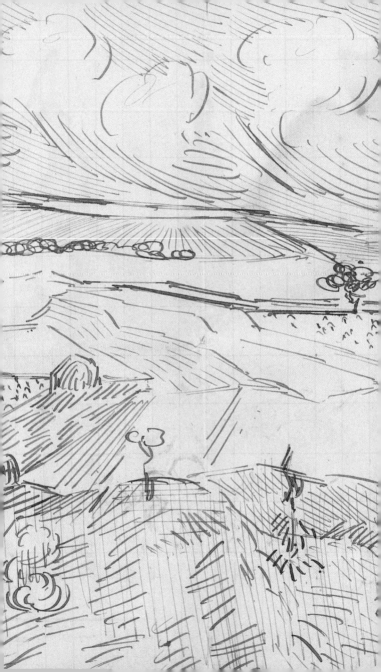

'But precisely for one's health, as you say – it's very necessary to work in the garden and to see the flowers growing.

'For my part, I'm wholly absorbed in the vast expanse of wheatfields against the hills, large as a sea, delicate yellow, delicate pale green, delicate purple of a ploughed and weeded piece of land, regularly speckled with the green of flowering potato plants, all under a sky with delicate blue, white, pink, violet tones.

'I'm wholly in a mood of almost too much calm, in a mood to paint that.'

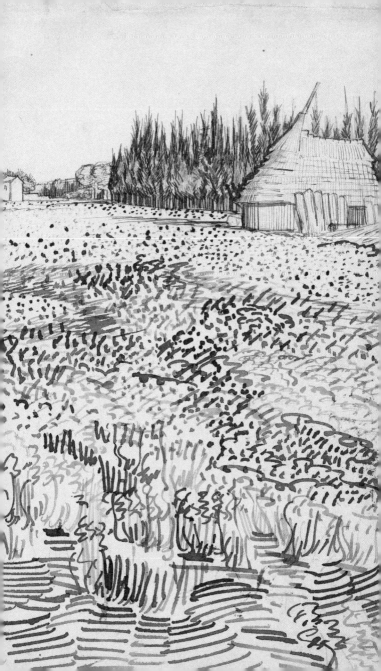

'I would wish that you might see the silent heath that I see through the window here, because such a thing soothes one and inspires more faith, resignation, calm work. …

'How I wish that we could walk together here and – paint together. I believe that the countryside would win you over and convince you.'

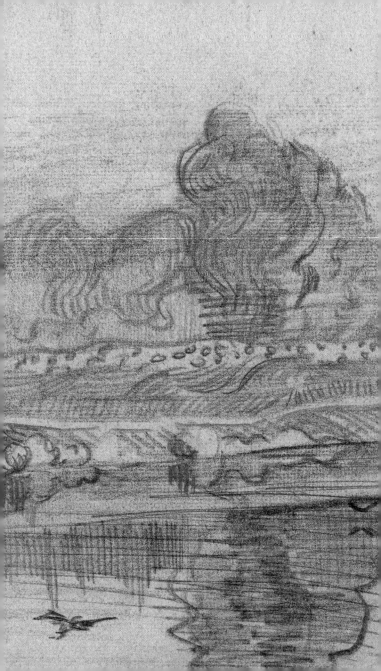

'Do you think it strange of me that I
dare to say as much as this: now, at the
very beginning, change course *now* and
no later than now in so far as you work
at restoring the bond between yourself
and nature? The more you remain in
the frame of mind of not being part
of nature, the more you play into the
hands of your eternal enemy (and mine
too), Nerves.'

'One thing I tell you, that this
countryside has the effect on me of
bringing me peace, faith, courage, and
I believe you also need this influence
yourself – it would be the very, very
best thing for you – let you find yourself,
your soul again …'

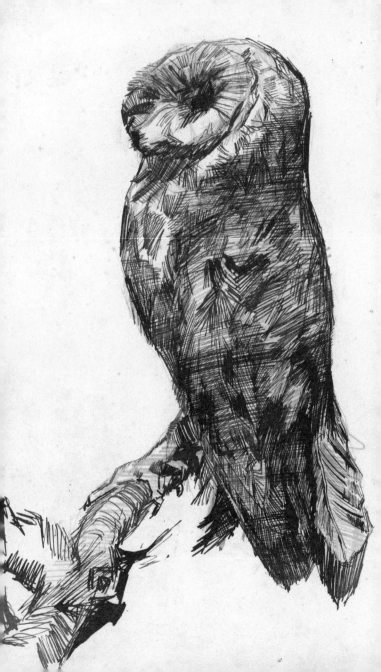

'What moulting is to birds, the time
when they change their feathers, that's
adversity or misfortune, hard times, for
us human beings. One may remain in
this period of moulting, one may also
come out of it renewed, but it's not
to be done in public, however; it's
scarcely entertaining, it's not cheerful,
so it's a matter of making oneself scarce.
Well, so be it.'

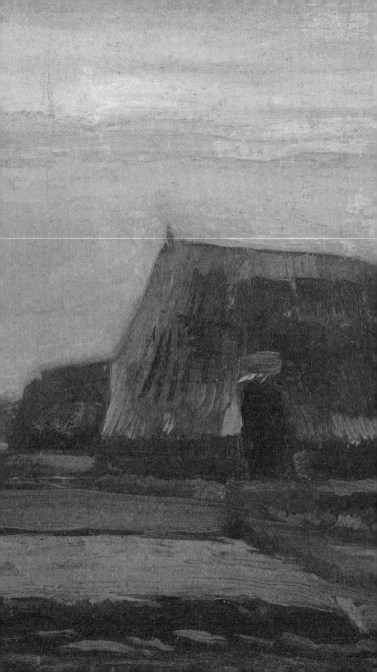

'As for me, old chap – although the mill
has gone and with it the years and my
past youth, just as irrevocably – what
has reawakened deep inside me is the
belief that there's something good
and that it's worthwhile making an
effort and doing one's best to take life
seriously. This is now perhaps, or rather
certainly, more firmly rooted in me than
in the past, when I had experienced less.
For me the point now is to express the
poetry of those days in drawings.'

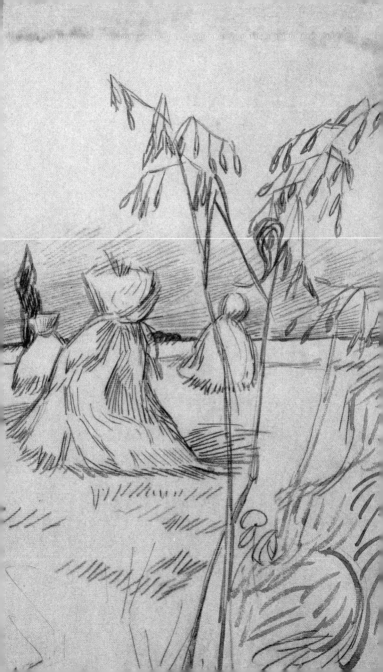

'You see for yourself in nature that many a flower is trampled, freezes or is parched, further that not every grain of wheat, once it has ripened, ends up in the earth again to germinate there and become a stalk – but far and away the most grains do *not* develop but go to the mill – don't they?

'Now comparing people with grains of wheat – in every person who's healthy and natural there's *the power* to *germinate* as in a grain of wheat. And so natural life is *germinating*.

'What the power to germinate is in wheat, so love is in us.'

BEAUTY

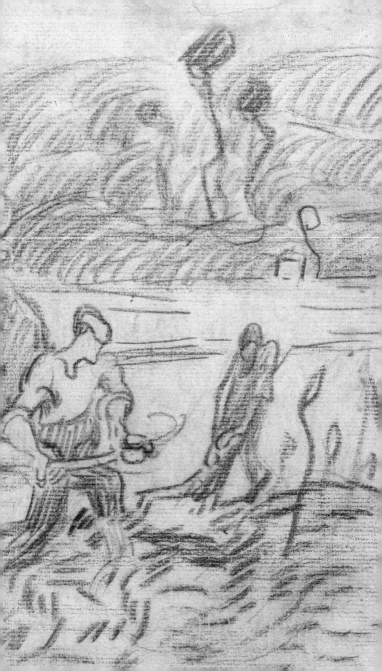

'It's so beautiful here, if only one has a good and a single eye, without many beams in it.

'But if one has that, then it's beautiful everywhere.'

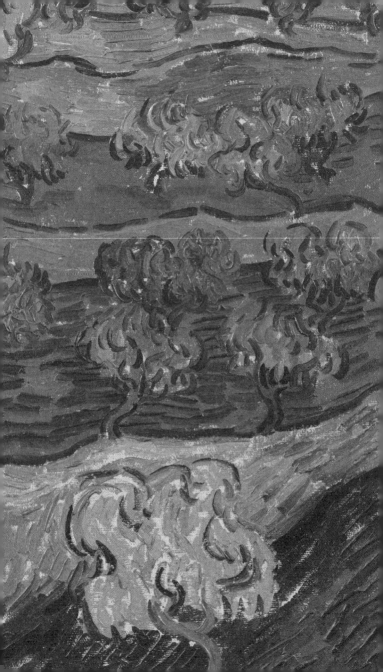

'And by working very calmly, beautiful
subjects will come of their own accord
… I've let myself become thoroughly
imbued with the air of the small
mountains and the orchards. With that,
I'll see. My ambition is truly limited
to a few clods of earth, some sprouting
wheat. An olive grove.'

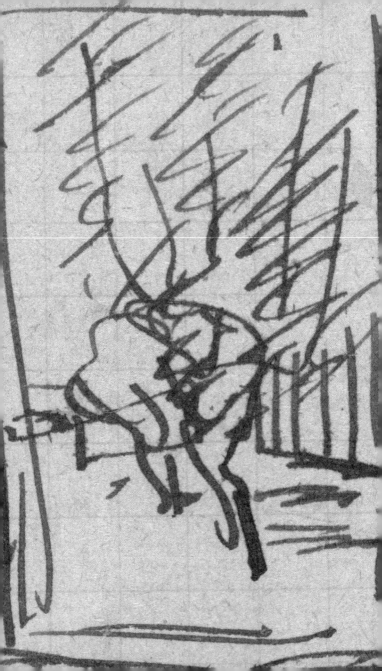

'… as for the subjects of orchards in blossom. I have a lot of trouble painting because of the wind, but I fix my easel to pegs stuck in the ground and work anyway, it's too beautiful.'

Rembrandt. je viendrai bien connaît
tableau et savoir à quelle époque de
peint. Tout cela rentre avec le[s]
de Fabritius de Rotterdam le roy
la galerie Lacaze dans une cadre
spéciale où le portrait d'un
humain se transforme en l[e]
qui de lumineux et de consola
Et comme cela est très différan
michel ange ou de Giotto qu[e]
e dernier s'en rapproche pour
k qu'ainsi Giotto forme com
rait d'union ... en[tre] ... entre
de Rembrandt & les italiens.

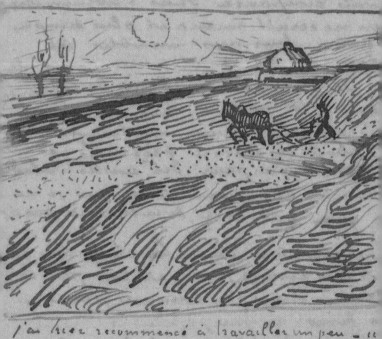

j'ai trez recommencé à travailler un peu _ ce
que je vois de ma fenêtre _ un champ de cha
qu'on laboures l'opposition de la terre labou
avec les bandes de chaume jaune par
colines.

'Yesterday I started working again a little – a thing I see from my window – a field of yellow stubble which is being ploughed, the opposition of the purplish ploughed earth with the strips of yellow stubble, background of hills.

'Work distracts me infinitely better than anything else, and if I could once really throw myself into it with all my energy that might possibly be the best remedy.'

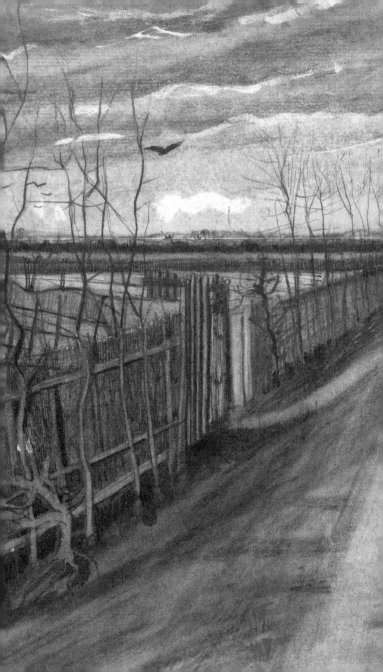

'How beautiful it is outside I sometimes yearn for a country where it would always be autumn, but then we'd have no snow and no apple blossom and no corn and stubble fields.'

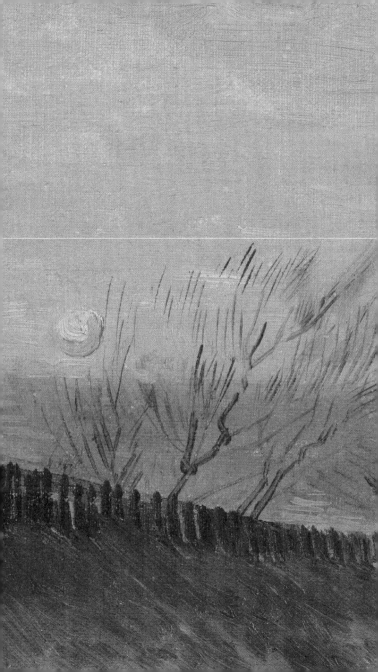

'The beautiful evenings have returned;
the trees are beginning to uncurl their
buds. Hyacinths, daffodils, violets and
lilacs scent the flower-sellers' stalls;
the crowds have begun to stroll along
the quays and boulevards again. After
supper, I too came down from my garret
to breathe the evening air.'

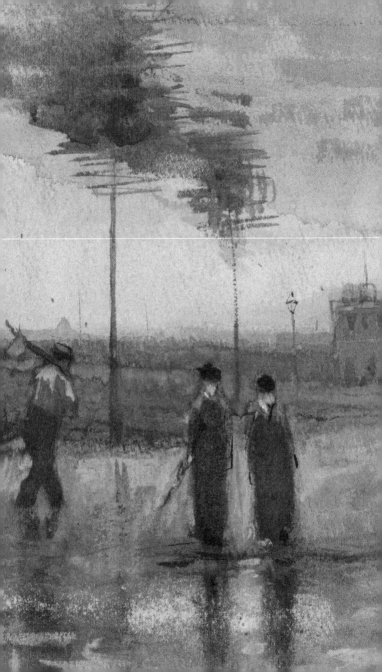

'How beautiful it is outdoors when
everything is wet with rain – before –
during – after the rain. I really ought
not to miss a single shower.'

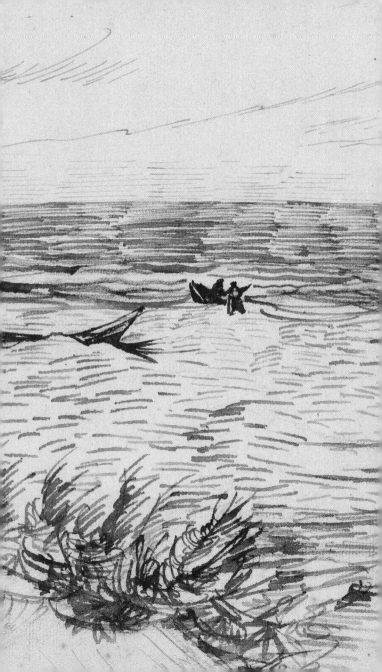

'I took a walk along the seashore
one night, on the deserted beach.
It wasn't cheerful, but not sad either,
it was – beautiful.

'The sky, a deep blue, was flecked with
clouds of a deeper blue than primary
blue, an intense cobalt, and with others
that were a lighter blue – like the blue
whiteness of milky ways. Against the
blue background stars twinkled, bright,
greenish, white, light pink – brighter,
more glittering, more like precious
stones than at home – even in Paris.
So it seems fair to talk about opals,
emeralds, lapis, rubies, sapphires.
The sea a very deep ultramarine – the
beach a mauvish and pale reddish shade,
it seemed to me – with bushes.'

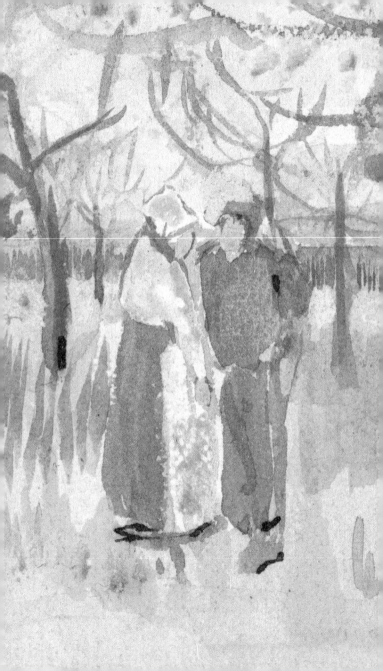

'There's nothing more beautiful than nature early in the morning.'

PEACE

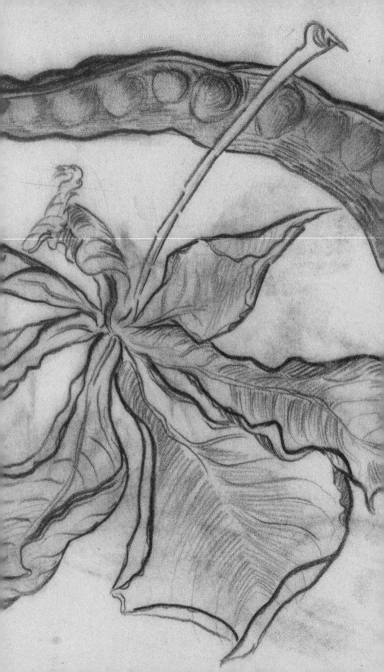

'What I find beautiful is everywhere here.
That's to say, there is *peace* here.'

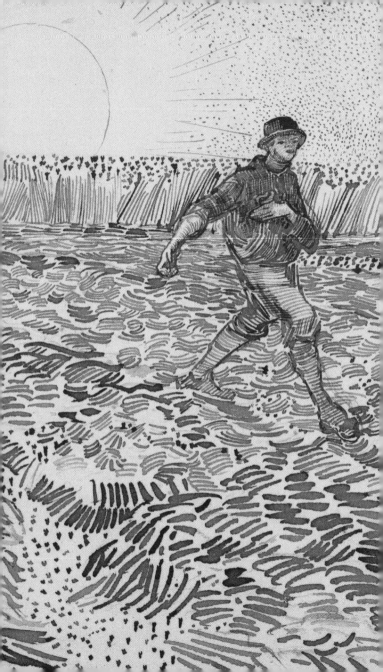

'The country is superb, superb, everything calls out to you: paint! So distinctive and so varied. Look, old chap, however things go, aren't there always financial difficulties everywhere, and where are they less than here, and where or how on earth can a time of struggle lead to a more permanent peace? To a great peace that no one can disturb.'

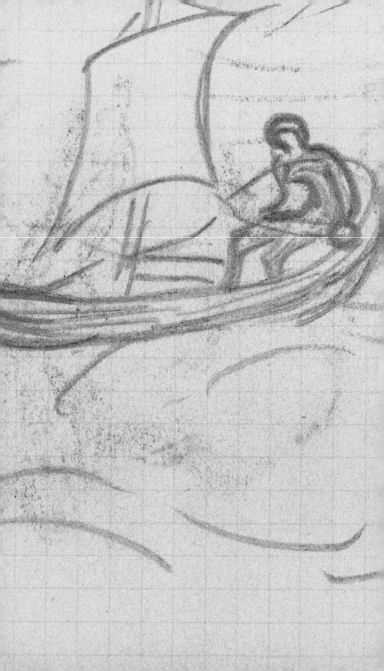

'Then I also painted a study of a
seascape, nothing but a bit of sand, sea,
sky, grey and lonely – sometimes I feel
a need for that silence – where there's
nothing but the grey sea – with an
occasional seabird. But otherwise,
no other voice than the murmur of
the waves.'

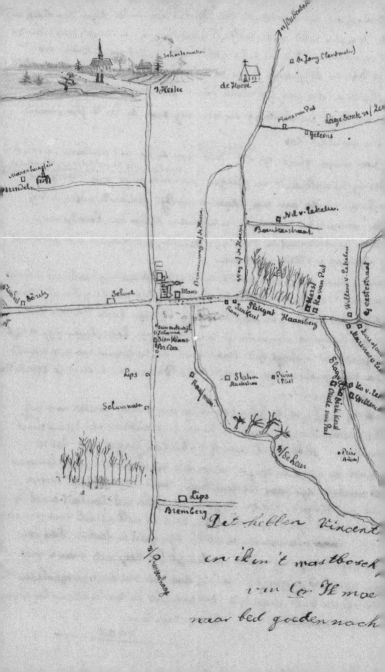

Dit hebben Vincent

en ik in 't mastbosch,

van Co. Ik moe

naar bed goeden nacht

'In the evening, when we rode back
from Zundert over the heath, Pa and
I walked a way, the sun set red behind
the pines and the evening sky was
reflected in the marshes, the heath and
the yellow and white and grey sand were
so resonant with tone and atmosphere.
You see, there are moments in life when
everything, within us too, is peace and
atmosphere, and all of life seems to be
like a path across the heath, though it
isn't always so.'

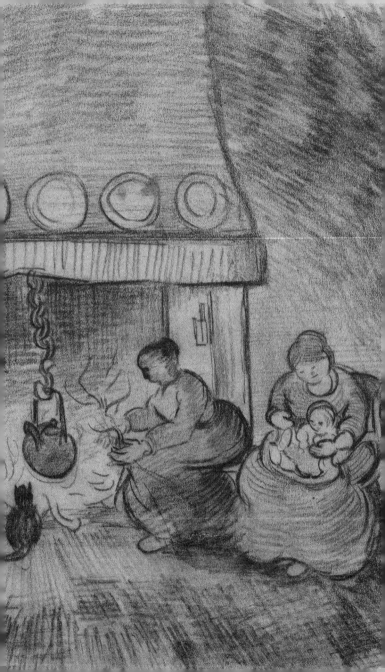

'And then, when dusk fell – imagine the
silence, the peace of that moment!'

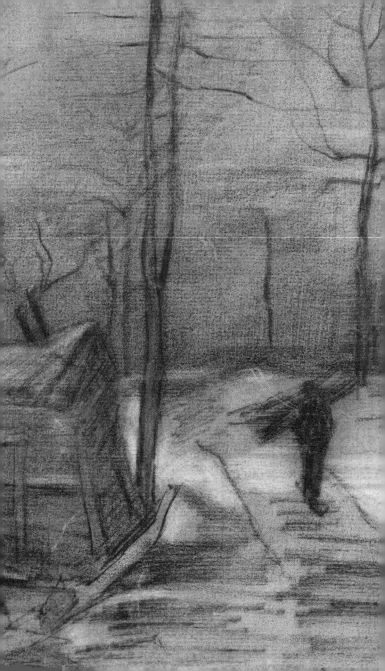

'The sky was an inexpressibly delicate lilac white – not fleecy clouds, because they were more joined together and covered the whole sky, but tufts in tints more or less of lilac – grey – white – a single small rent through which the blue gleamed. Then on the horizon a sparkling red streak – beneath it the surprisingly dark expanse of brown heath, and a multitude of low roofs of small huts standing out against the glowing red streak. ...

'But what tranquillity, what breadth, what calm there is in nature here ...'

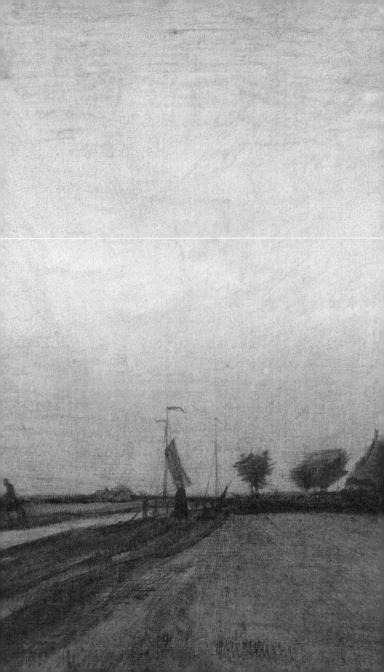

'In my view, there's nowhere one can
think better than by a peasant hearth,
with a baby in an old cradle beside
it – and where one can see through the
window a delicate green wheatfield and
the alder bushes waving.'

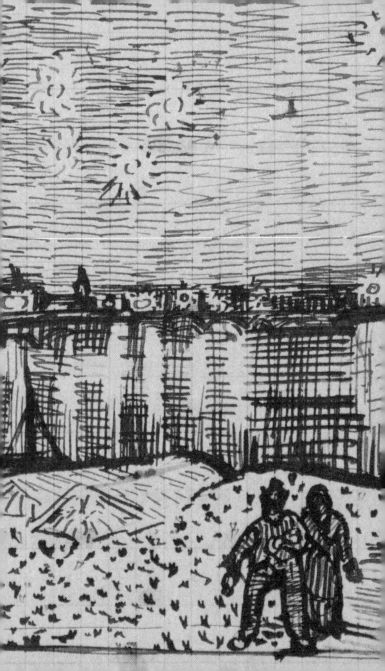

'But the sight of the stars always makes me dream *in as simple a way* as the black spots on the map, representing towns and villages, make me dream.'

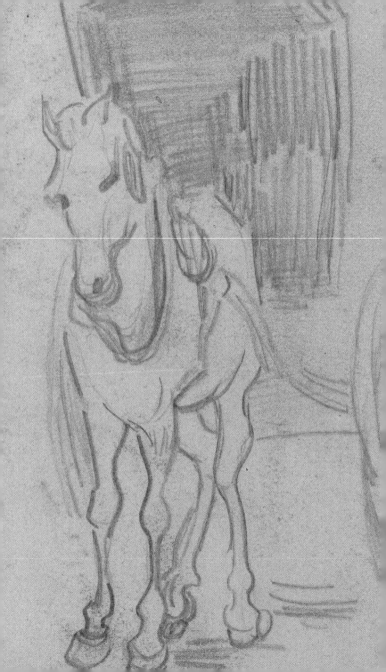

'When one travels for hours and hours through the region, one feels as if there's actually nothing but that infinite earth, that mould of wheat or heather, that infinite sky. Horses, people seem as small as fleas then. One feels nothing any more, however big it may be in itself, one only knows that there is land and sky.'

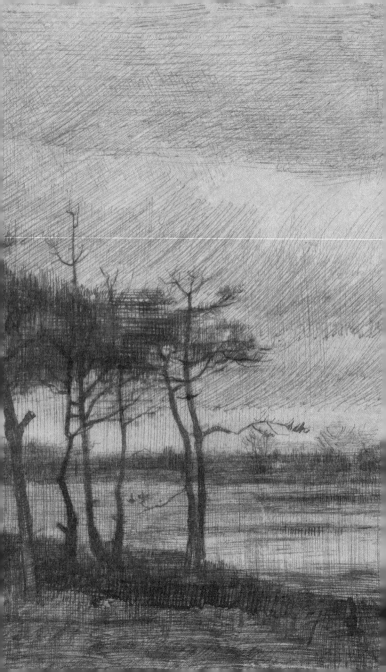

'… I sometimes have a certain sense of being abandoned, but on the other hand it concentrates my attention on the things that aren't changeable, namely the eternal beauty of nature.'

TRANSCENDENCE

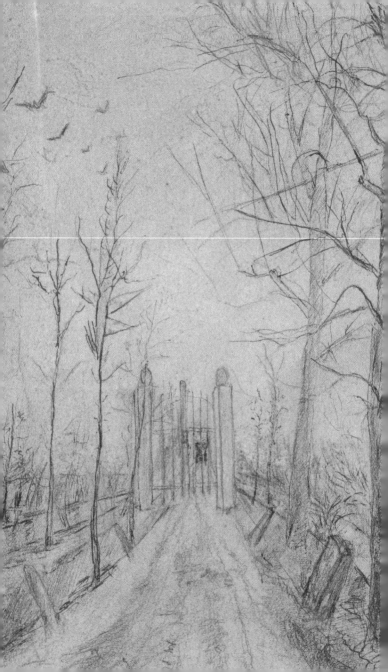

'Feeling, even a fine feeling, for the beauties of nature isn't the same as religious feeling, although I believe that the two are closely connected. The same is true of a feeling for art. Don't give in to that *too* much either.'

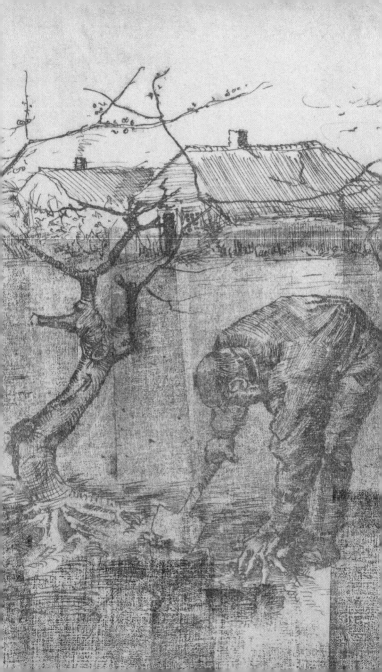

'I have spent three months on the heath:
you know, that lovely region where the
soul returns to itself and enjoys sweet
repose; where everything exudes peace
and tranquillity; where the soul, in the
presence of God's immaculate creation,
shakes off the yoke of convention,
forgets society and frees itself from
its bonds with the vigour of returning
youth; where every thought takes on
the form of prayer; where the heart is
emptied of everything that is not in
harmony with the freshness and freedom
of nature.'

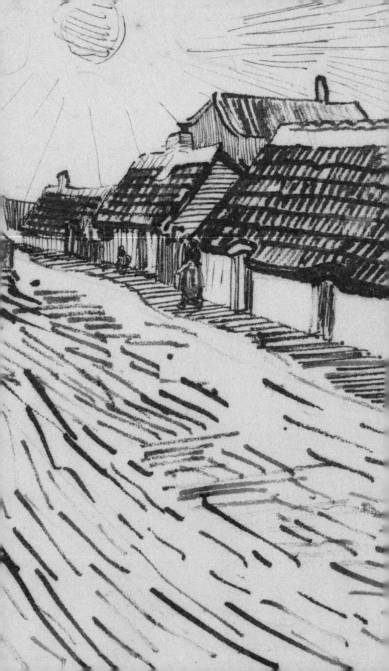

' ... here on the silent heath where I feel
God high above you and me.'

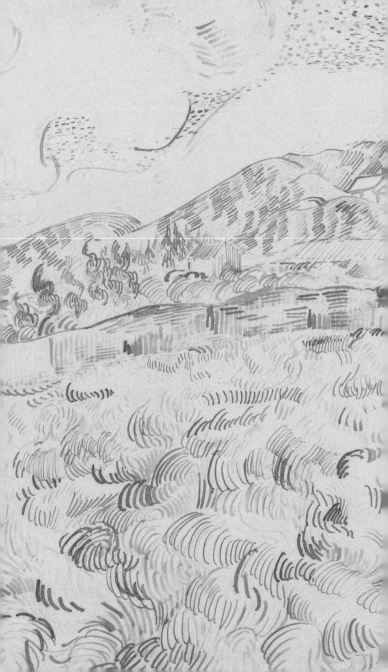

'And it does me good to do what's *difficult*. That doesn't stop me having a tremendous need for, shall I say the word – for religion – so I go outside at night to paint the stars …'

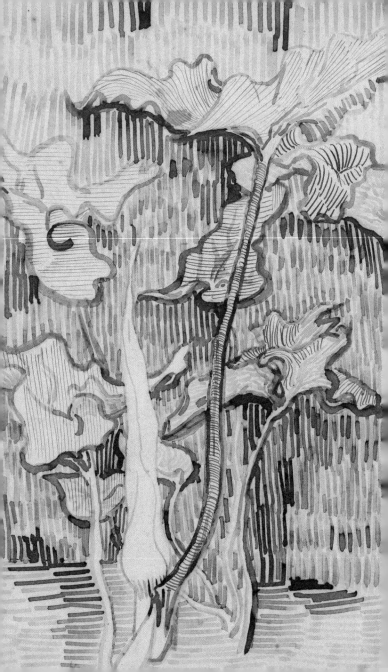

'There's hope … in the stars. I find that true, and well said, and beautiful; and what's more, I readily believe it myself, too.

'But let's not forget that the earth's a planet too, therefore a star or celestial globe. And what if all these other stars were the same!!!!!! It wouldn't be very jolly, in fact you'd have to start all over again.'

Mon cher Theo, je rentre d'une journée à Mont Majour et mon ami
le sous lieutenant m'a tenu compagnie. Nous avons alors à nous
deux exploré le vieux jardin et y avons volé d'excellentes figues. Si c'eût été
plus grand cela eut fait penser au Paradou de Zola, de grands roseaux
de la vigne du lierre des figuiers des oliviers des grenadiers aux
fleurs grasses du plus vif orangé, des ~~vieux~~ cyprès centenaires
des frênes et des saules des chênes de roche, des escaliers
écroulés à demi des fenêtres ogivales en ruines, des blocs
de blanc rochers couverts de lichen et des pans de murs
écroulés épars çà et là dans la verdure. j'en ai encore rapporté un gra-
-nd dessin. non pas du jardin cependant. Cela me fait 3 des-
-sins que j'en aurai demi douzaine les enverrai.
Hier j'ai été à Fontvieilles pour faire une visite à B
et Mac Knight seulement ces messieurs étaient partis pour
jours pour un petit voyage en Suisse.

Je crois que la chaleur me fait toujours du bien
malgré les moustiques et les mouches.

Les cigales - non pas celles de chez nous mais des
comme ceci ces cigales (je crois que
les vois sur les albums japonais) leur nom est cicada)
des Cantharides chantent au moins au-
-rées et vertes en fort qu'une grenouille
j'en vois sur les oliviers.

'Since, however, nothing stands in the
way – of the supposition that on the
other innumerable planets and suns
there may also be lines and shapes and
colours – we're still at liberty – to
retain a relative serenity as to the
possibilities of doing painting in better
and changed conditions of existence –
an existence changed by a phenomenon
perhaps no cleverer and no more
surprising than the transformation of
the caterpillar into a butterfly, of the
white grub into a cockchafer.'

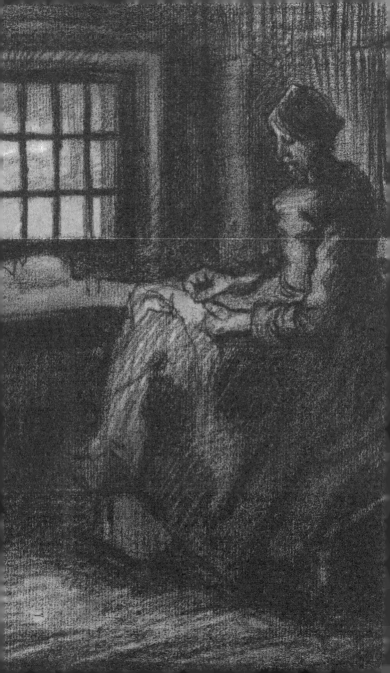

'In the evening there's also a beautiful
view of the yard, where everything is
deathly still and the street-lamps are
burning and the sky above full of stars.
When all sounds cease – God's voice is
heard – Under the stars.'

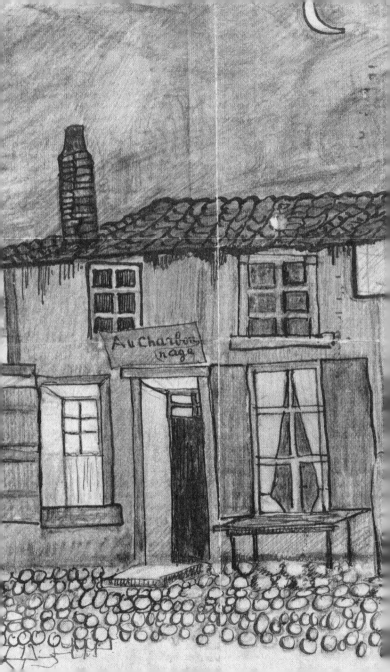

'… everything changes the moment the stars come out …'

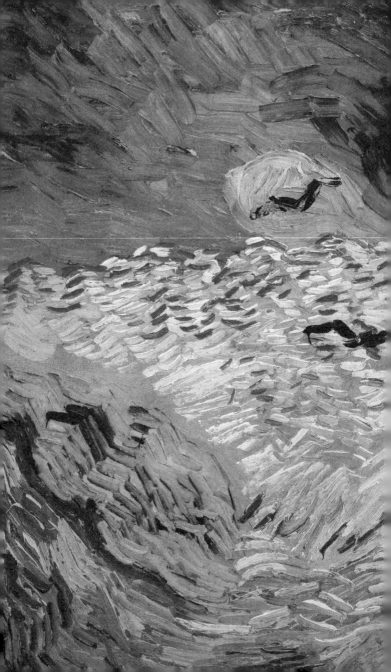

'The moon still shines now, and the sun
and the evening star, which is fortunate,
and they often speak of God's Love and
call to mind the words, lo, I am with you
alway, even unto the end of the world.'

CREDITS

Letters

Letter fragments from digital edition: *Vincent van Gogh, The Letters.* Ed. Leo Jansen, Hans Luijten and Nienke Bakker. Amsterdam 2009. The letters are translated from Dutch and French to English by the Van Gogh Letters Project, www.vangoghletters.org.

11 (#492) to his brother Theo, 9 April 1885 • 13 (#076) to his brother Theo and sister Anna, 17 April 1876 • 15 (#533) to Theo, 4 October 1885 • 17 (#211) to Theo, 11 March 1882 • 19 (#414) to Theo, 16 December 1883 • 21 (#387) to Theo, 16 September 1883 • 23 (#369) to Theo, 29 and 30 July 1883 • 25 (#211) to Theo, 11 March 1882 • 27 (#413) to Theo, 15 December 1883 • 29 (#856) to his sister Willemien, 19 February 1890 • 31 (#083) to Theo, 31 May 1876 • 35 (#017) to Theo, beginning of January 1874 • 37 (#396) to Theo, 15 October 1883 • 39 (#155) to Theo, between 22 and 24 June 1880 • 41 (#291) to Theo, between 4 and 9 December 1882 • 43 (#296) to Theo, on or about 27 December 1882 • 45 (#252) to Theo, 31 July 1882 • 47 (#175) to Theo, 12 and 15 October 1881 • 49 (#288) to Theo, 26 and 27 November 1882 • 51 (#837) to Willemien, 4 January 1890 • 53 (#687) to Theo, 25 September 1888 • 55 (#251) to Theo, 26 July 1882 • 59 (#451) to Theo, 2 July 1884 • 61 (#779) to Theo, 9 June 1889 • 63 (#257) to Theo, 14 August 1882 • 65 (#252) to Theo, 31 July 1882 • 67 (#397) to Theo, 16 October 1883 • 69 (#663) to Theo, 18 August 1888 • 71 (#537) to Theo, 28 October 1885 • 73 (#492) to Theo, 9 April 1885 • 75 (#RM21) to his friend Joseph Jacob Isaäcson, 25 May 1890 • 77 (#657) to Theo, 8 August 1888 • 81 (#259) to Theo, 26 August 1882 • 83 (#170) to Theo, 5 August 1881 • 85 (#896) to Theo and Theo's wife, Jo, 2 July 1890 • 87 (#329) to his friend Anthon van Rappard, 15 or 16 March 1883 • 89 (#833) to Theo, 31 December 1889 or 1 January 1890 • 91 (#104) to Theo, 28 February 1877 • 93 (#172) to Theo, mid-September 1881 • 95 (#126) to Theo, 5 August 1877 • 97 (#397) to Theo, 16 October 1883 • 99 (#250) to Theo, 23 July 1882 • 101 (#665) to his friend Émile Bernard, 21 August 1888 • 105 (#120) to Theo, 12 June 1877 • 107 (#394) to Theo, 12 October 1883 • 109 (#260) to Theo, 3 September 1882 • 111 (#898) to Theo and Jo, 10 July 1890 • 113 (#899) to his mother Anna and sister Willemien, 10 and 14 July 1890 • 115 (#392) to Theo, 3 October 1883 • 117 (#394) to Theo, 12 October 1883 • 119 (#406) to Theo, 12 or 13 November 1883 • 121 (#155) to Theo, between 22 and 24 June 1880 • 123 (#250) to Theo, 23 July 1882 • 125 (#574) to Willemien, late October 1887 • 129 (#027) to Theo, 31 July 1874 • 131 (#822) to Émile, on or about 26 November 1889 • 133 (#591) to Theo, on or about 1 April 1888 • 135 (#798) to Theo, on or about 2 September 1889 • 137 (#273) to Anthon, on or about 22 October 1882 • 139 (#093) to Theo, 7 and 8 October 1876 • 141 (#258) to Theo, 20 August 1882 • 143 (#619) to Theo, on or about 3 or 4 June 1888 • 145 (#356) to Theo, 22 June 1883 • 149 (#393) to Theo, on or about 7 October 1883 • 151 (#396) to Theo, on or about 15 October 1883 • 153 (#264) to Theo, 17 September 1882 • 155 (#145) to Theo, 22 July 1878 • 157 (#402) to Theo, 2 November 1883 • 159 (#392) to Theo, on or about 3 October 1883 • 161 (#399) to Theo and Anna, on or about 26 October 1883 • 163 (#638) to Theo, 9 or 10 July 1888 • 165 (#402) to Theo, 2 November 1883 • 167 (#267) to Anthon, on or about 19 September 1882 • 171 (#049) to Theo, 17 September 1875 • 173 (#093) to Theo, 7 and 8 October 1876 • 175 (#401) to Theo, on or about 31 October 1883 • 177 (#691) to Theo, on or about 29 September 1888 •

179 (#642) to Theo, 15 July 1888 • 181 (#632) to Émile, 26 June 1888 • 183 (#119) to Theo, 4 and 5 June 1877 • 185 (#093) to Theo, 7 and 8 October 1876 • 187 (#121) to Theo, 9 July 1877.

Images

Images by Vincent van Gogh, from Van Gogh Museum, Amsterdam (Vincent van Gogh Foundation), © Van Gogh Museum®.

6 *Pine Cone*, 1889–90 • 10 *Sunflowers*, 1890 • 12 *Landscape with a Stack of Peat and Farmhouses*, 1883 • 14 *Bird's Nest* (letter #533), 1885 • 16 *Old Nag*, 1883 • 18 *Landscape with Cypresses and Studies of Figures*, 1890 • 20 *Figures on the Beach*, 1890 • 22 *Breakwater* (letter #369), 1883 • 24 A. *Farm*; B. *Rider by a Waterway*; C. *Woman and Child*; D. *Head of a Woman*; E. *Woman Working*; F. *Country Road with Cottages*, 1883 • 26 *Woman Walking her Dog* ('A La Viellete'), 1886 • 28 *Sunflowers Gone to Seed* (letter #392), 1887 • 30 *Four People on a Bench*, 1992 • 34 *Avenue in a Park*, 1888 • 36 A. *Ploughman with a Stooping Woman*; B. *Farm with Stacks of Peat* (letter #396), 1883 • 38 *Four Swifts with Landscape Sketches*, 1887 • 40 *Periwinkle*, 1889 • 42 *Thistles by the Roadside*, 1888 • 44 *Pollard Willow* (letter #252), 1882 • 46 *The Vicarage Garden*, 1884 • 48 *The Kingfisher*, 1884 • 50 *Field with Farmhouses*, 1888 • 52 *Olive Grove*, 1889 • 54 *Bleaching Ground* (letter #251), *1882* • 58 *Blossoming Peach Trees*, 1888 • 60 *Tree with Ivy in the Garden of the Asylum*, 1889 • 62 *Sunset Over a Meadow* (letter #257), 1882 • 64 *Vase with Honesty*, 1884 • 66 *Stooping Woman in a Landscape* (letter #397), 1883 • 68 *Landscape with Houses*, 1890 • 70 *Kingfisher by the Waterside*, 1887 • 72 *Two Women Working in the Fields*, 1885 • 74 *Olive Trees with the Alpilles in the Background*, 1889 • 76 *Landscapes with Houses*, 1890 • 80 *Fishing Boats on the Beach* (letter #251), 1882 • 82 *Garden of a Bath House*, 1888 • 84 *Couple with Child, Walking in the Rain*, 1890 • 86 *Hand with a Bowl, and a Cat*, 1885 • 88 *Provençal Orchard*, 1888 • 90 *Landscape with a Church*, 1883 • 92 *Miners in the Snow: Winter*, 1882 • 94 *Interior with Three Figures at a Table*, 1890 • 96 *Cradle with Child by the Stove*, 1885 • 98 *Rooftops* (letter #251), 1882 • 100 *Allotment with Sunflower*, 1887 • 104 *The De Ruijterkade in Amsterdam*, 1885 • 106 *Studies of a Dead Sparrow*, 1889–90 • 108 *La Crau Seen from Montmajour*, 1888 • 110 *Wheatfield under Thunderclouds*, 1890 • 112 *Wheatfields* (letter #902), 1890 • 114 *Landscape with Hut*, 1888 • 116 *Landscape with the River Oise*, 1890 • 118 *Man Pulling a Harrow* (letter #400), 1883 • 120 *Barn Owl Viewed from the Side*, 1887 • 122 *Farm with Stacks of Peat*, 1890 • 124 *Field with Sheaves of Wheat*, 1890 • 128 *Landscape with Peasants Reaping*, 1890 • 130 *Olive Trees on a Hillside*, 1889 • 132 *Three Orchards*, 1888 • 134 *Field with a Ploughman* (letter #798), 1889 • 136 *Country Road*, 1882 • 138 *Sunset in Montmartre*, 1887 • 140 *A Sunday in Eindhoven*, 1885 • 142 *Beach at Les Saintes-Maries-de-la-Mer*, 1888 • 144 *Orchard in Blossom with Two Figures: Spring*, 1882 • 148 *Chestnut Leaf with Pod*, 1889 • 150 *The Sower*, 1888 • 152 *Fishing Boat*, 1890 • 154 *Map of Etten and Environs* (letter #154), 1878 • 156 *Figures by the Fireplace*, 1890 • 158 *Winter Landscape with Hut and Figure*, 1881 • 160 *Landscape in Drenthe*, 1883 • 162 *Starry Night Over the Rhône* (letter #693), 1888 • 164 *Horse and Carriage*, 1890 • 166 *Pine Trees in the Fen*, 1884 • 170 *Driveway*, 1872–73 • 172 *Gardener by an Apple Tree*, 1883 • 174 *Houses in the Sun in Les Saintes-De-La-Mer*, 1888 • 176 *The Enclosed Wheat Field After a Storm*, 1889 • 178 *Arums*, 1889 • 180 *Cicada* (letter #638), 1888 • 182 *Woman Sewing*, 1885 • 184 *The 'Au Charbonnage' Café in Laken*, 1878 • 186 *Wheatfield with Crows*, 1890 • 192 *Almond Tree and Wall in the Garden of the Asylum*, 1889.

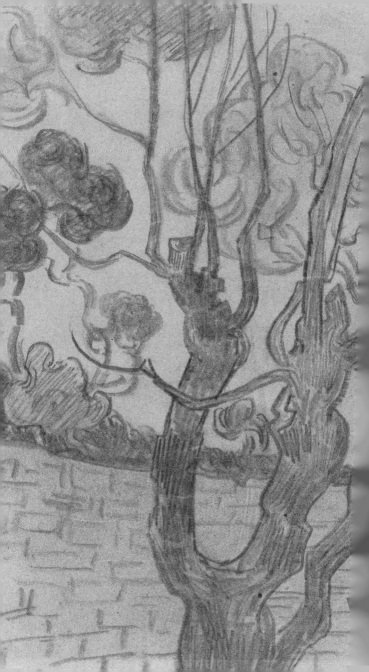